NORA TURATO

GOVERN ME HARDER

CLARION

NORA TURATO

Curator's Note: Modernism Unraveling
Ebony L. Haynes

I remember the first time I read about the Pruitt-Igoe housing development in St. Louis, a federally funded complex that proposed an innovative solution to the lack of subsidized and accessible housing. Within a decade of its opening, living conditions had declined so dramatically that, in 1972, the majority of the buildings were demolished, in a televised spectacle. This continues to be an example, in my mind, of a failed attempt at modernism, or an unraveling of a traditional form, system, or idea—a project that turns into a parody of itself.

Nora Turato's *govern me harder*—52 Walker's third exhibition—embraced the destruction of assumptions and made a performance of first impressions with artworks that play with ideas of realism, form, and context. Through her practice, the artist simultaneously reduces and amplifies the omnipresent nature of typography and graphic design. This exhibition took stock of how power and order are communicated through this medium, exploding and recontextualizing the language we encounter daily.

Working on this exhibition with Turato involved a sequence of events that aimed to break ties with expectation. One such break took the form of font. Early in our exchanges, we talked about how Helvetica is widely understood to be the gold standard of modernist type. By 1960, the typeface had become an icon of Swiss design, and it now has dozens of variants. The first thing Turato confirmed for the exhibition was the creation of a new typeface: Helvetica52.

Turato created this bespoke typeface in collaboration with the Amsterdam-based Jung-Lee Type Foundry and with consultation from the graphic designer Sabo Day. It riffs on the clean, sans serif letters and characters of Helvetica. The basic Helvetica52 letter cut was used for the wall murals on view in the gallery and is available for the public to download; the "monster cut" stretches, drips,

and echoes. While Helvetica is intended to be legible and accessible, the monster cut dances and bleeds, sometimes making it difficult to discern letters and words. Both the basic and monster cuts of Helvetica52 became the brushes with which Turato created these works.

As for many artists, a work might begin as a sketch. In Turato's case, she utilizes a script, the written word and speech, to conceive her works. Seemingly free-associative but in fact deliberate, Turato's endless snarl of words is culled from social-media platforms, news headlines, exhibition press releases, and her own thoughts, among other sources. With phrases such as "all is forgiven" and "you're so vain," the enamel panels are so shiny you'd think you could skate on them. But there's also something *juicy* about them. At first glance, they look like industrial signs, manufactured completely by machines, but they are perfectly imperfect, created by the human hand.

The murals, which tout quotes from movies, were an optical illusion. Some visitors to the gallery were sure the murals were vinyl decals, or at least that the imagery was projected onto the wall and then painted. In reality, the murals were made with hand-cut paper stencils, painter's tape, X-ACTO knives, paint, brushes, and rollers. Turato often turns realism into a parody, leaving viewers pondering how something is made or reading the quotes as if they were pop-culture debris, and in the process breaks from some of the rigidity that comes with perfect lines.

The scripts illustrated in this book provide a window onto Turato's drawing board, where ideas, colors, and phrases take shape. The lines of text are coded, and even though only the artist holds the key, for this volume of *Clarion* we invite you to look closely at the connection between these texts and the works in the exhibition. A generous essay by Anna Kats dives into the influences and considerations of Turato's performative work. Examining themes from punk and graphic design to dog walking and protein bars, Kats opens up the reasoning for Turato's unraveling. Through text and speech, Turato highlights the tension between form and content. When meticulously crafted and installed, her work performs realness.

Nora Turato, Word Processor
Anna Kats

Not every artist keeps her subject in reserve, but Nora Turato works with words and hoards them, too. For her solo presentation at 52 Walker, Turato pulled out choice bits of text she has had parceled away for years in her artefactual repertoire. Arranged in rapid succession across the gallery walls, as though they belong together, Turato's words acquired a dramatic temperament that belies their stochastic ordering.

In her wall-mounted enamel pieces and mural installations, as in her live spoken word performances, Turato collapses dialogue into monologue. She does so without articulating, in the process, a singular "I." Watching and listening to Turato perform hardly outlines the contours of her character's specific, individual persona—that is, she does not trade in poetic applications of figurative language. Her rejection of lyricism and individual subjectivity across the media of her artistic practice is necessarily connected; Turato does not model artistic creativity as some kind of inward turning.

Before she called herself an artist, Turato was a teenage punk. Rijeka, her hometown in Croatia—and home to influential Yugoslav punk and New Wave scenes—remains a seat of underground music and youth subculture. At fifteen, Turato founded her own noise band, serving as its bassist, lead vocalist, recording engineer, and tour manager. She composed the music, wrote the songs, and performed in public for the first time. She loved it. Turato continued to record music well into her graduate studies in graphic design in the Netherlands. In the summer of 2022—after an extended period dedicated to technical training in the thespian and vocal skills central to her spoken word performance practice—Turato returned daily to music, piano practice, and song.

Describing her early musical formation, Turato cites the late 1980s Croatian pop band Electro Team. "ET sounds exactly like a version of something that exists in the West," Turato explains, "but there was something a bit off about it, like the channel is wrong."[1] By way of illustration, she sang a bar of melodic pseudo-speech. I heard what she intended: an ambiguously familiar yet

incomprehensible refrain suggestive of the sound of language, but not one found in any known lexicon. Biographic as it might be, the method of this mnemonic relates to Turato's work in general. In her oeuvre, the word is consistently subordinated to the drama of its textual delivery—aural and visual—and units of language are sublimated into a symphonics of spoken effects. Though she is pointedly not a historicist, her project is deeply of, and perhaps "off," many modernist gambits of language in art, literature, and poetry.[2]

When Turato was born, in 1991, Zagreb had newly been installed as the capital of postsocialist Croatia. The breakup of the Socialist Federal Republic of Yugoslavia colored the regional media landscape and domestic cultural climate of her childhood in Rijeka, a northwestern coastal city with an active, commercially important port and a history of cultural exchange with nearby Italy. Turato came of age as the crucial cultural-political western boundary of Europe was being renegotiated.[3] After World War II, Yugoslavia modeled itself as the "land of the in-between" with its market socialism and nonalignment with both the capitalist and Soviet-communist blocs.[4] With the collapse of its version of state socialism in 1991 and the dissolution of Yugoslavia into nation-states in the ensuing decade, the region's longstanding geopolitical status as intermediary between Western and Eastern Europe became a question of national orientation for the Yugoslav successor states to address as individual entities. In the scramble to calibrate its political, economic, and cultural affinities with Europe and to articulate a cohesive logic of national identity in the era of globalization, the Croatian government styled itself Occidentally, as Western Europe's easterly limit, by aggrandizing its Habsburg legacy and majority Catholic population.

In the climate of wartime precarity and economic transition that marked Turato's childhood, then, aspirational statist rhetoric about national unity, European integration, and geopolitical determinacy piled up into a heap of familiar if barely meaningful words. But there is something more specific to Turato's artistic choices than this context. When she moved to Amsterdam in

2009, to enroll at the Gerrit Rietveld Academie, her chosen course of study was something of a compromise. Under parental pressure to enter a profession, she chose graphic design because it was "the only thing that felt adjacent enough to music." She had initially wanted to pursue music full-time but knew that her parents would never allow it. "If I were born in Norway, then maybe I would have done whatever I wanted," Turato reflects. "But if you come from an upper-middle-class Croatian family that worked really hard to get where it is, they're not going to let you not study a viable profession." The undergraduate program allowed her time to continue composing and performing new music, and by 2012 Turato was involved with two side projects.

Words, however, were a problem. "I was making music, but I never wanted to write lyrics," she remembers. "I just wanted to sing." In 2016 Turato received her MFA in typography, the subfield of graphic design specifically concerned with the visual properties of textual elements. Famously experimental in its pedagogical methods, the program at Werkplaats Typografie, in Arnhem, helped to refine Turato's sensitivity to alphabetic language as a system of signification and an economy run on typefaces and fonts. Marketing jargon and sales motifs reappear throughout Turato's books, performances, wall works, and murals. What may appear therein as advertorial parody or pastiche in fact indexes her professional education in graphic design's contemporary commercial applications of the word as image.[5]

Turato's *pool* series of books were developed in response to her desire for language that amplified the formal properties of words while attenuating the typically dominant role of semantic meaning and context in the interpretation and circulation of language. For several years, Turato made a regular habit of writing down errant fragments of text or speech—excerpts from interpersonal encounters and social settings, personal reflection, and media outlets or information sources that informed her daily routines—which commandeered her attention or piqued her curiosity. At her undergraduate thesis show, where

Turato exhibited a video narrated by citations from her proverbial almanac of extracts, her professor Linda van Deursen suggested she try a dramatic reading of the script. Turato thus began to experiment with the performative translation of typography's textual logic: words as fodder for, not the product of, creativity. In doing so, she found a way around her indifference to composing original lyrics as well as a point of entry into the expansive arena of creative activity in which she now operates. "Graphic design gave me the freedom to be an artist," she told Ana Janevski, a curator at New York's Museum of Modern Art.[6] Yet the disciplinary conjunction of performance, installation, bookmaking, and graphics is still littered with words.

"In school I was not amazing at English; there were better students," Turato tells me. How did she first learn English? "I was into music, lyrics." Turato is a visual artist, professionally, and in this trade she is a native speaker of language's sound. As a result of Turato's reduction of language to its spectacular alphabetics, to its phatic fragments, her disinterest in lyric fluency becomes the embrace of a method in which subjectivity's many hiccups are necessarily entwined. Her idiom is mediated, and her methods of rhetorical appropriations might be identified with certain contemporary poets.[7] Still, Turato models straightforward expressivity of natural persons less than the cool technics of alienated heteroglossia, scripting an authorial voice that has already left the building. This is a difficult game to play in an Anglophone milieu whose core unit of expressive value remains the individual's progressive—and progressively comprehensible—arc.

Turato's work is cohered by an elaborate tissue of quotations, allusions, foreign phrases, and colloquial speech patterns. The salience of her prosody is in its capacity to insinuate meaning where sentence syntax would seem to indicate the absence thereof. Turato shares with pop art an impulse for found language, one that feels entitled to take up any measure of the written word as a kind of readymade. "I want to use the language, I don't want to make the language," she recently told me, as if to highlight the point postindustrially. For her scripts (see, for example, pp. 69–79), Turato assembles errant phrases and borrowed words as if they had just been plucked from a conveyer belt of mass-produced rhetoric. Yet she takes herself out of it: "It feels like I'm faking it more if I try to dig the words out of myself than if I'm just using them."

So what does she bricolage out of all that bric-a-brac? Her method makes operative the actually spoken of speech. Meaning, for Turato, comes not from the choice of particular words or discrete sentences (over any hypothetical possibility of others) but from the way they are uttered and rendered. Turato's performances achieve a ludic effect less by downplaying the significance of her monologue's content and more by privileging sound and aural delivery in the construction of meaning. In Turato's delivery, sound components have a semantic nature to themselves, rather than serving as a mere sensorily perceptible vehicle for meaning. By culling scraps of language that she consumes on social media, encounters in passing while walking her dogs or performing quotidian chores, or extracts from her own memory, Turato effectively assembles bodies of selectively appropriated text that deviate from conventionally utile language by self-reflexively foregrounding elements other than the referentially communicative. In her rigorously scripted but deceptively naturalistic live performances, Turato enters into what the German Japanese writer Yoko Tawada calls "the crevice between sound and language."[8]

Movement and gesture function as experimental variables in Turato's mimetic synthesis of word and sound components. The generative phonic logic of her work is similar to that of avant-garde Soviet *zaum* poets of the 1920s or postwar New York's concrete poets, applied at a historical remove. Yet Turato is adamant about the categorical differences between her and these groups: she is not a poet. "My end goal is the visceral quality of the letter, of the voice, of the vibration," she explains. Turato is voluble. "I'm more interested in *ahhhhhhh*"—she interjects an

acutely high-pitched trill to demonstrate how vocal-chord vibrations create a vibe, as it were—"than I am in writing." She doesn't much care for the word on a page, unless she can transform it—from text to graphic image, through locution or transposition—into an atmospheric effect. "I want to vibrate with words; I don't want to write them." Lexical elements are raw material in Turato's oeuvre, her means to an end.

Turato's scripts, when performed, serve to articulate the difference of various decontextualized fragments. The coherence of the performance is a function of its being observed and in turn *perceived* as a whole. Because her scripts offer no sense of narrative trajectory that would facilitate forward movement or a clear sense of progress, there is also no sense of resolution, or conclusion. Indeed, their structural logic disregards linear time altogether.

And what about the time of history? For the most part, Turato's points of reference and sources of appropriation are located in the immediate moment. Critics and curators have made much of the internet as a generative site for her practice, in turn overstating its significance in this context. Insofar as her practice has been provisionally historicized, reviewers generically draw on canonical precedents such as Andy Warhol, Marcel Duchamp, or Carolee Schneeman to make sense of Turato's preoccupation with mass media across multiple artistic media (even as such gestures at hegemonic modernist protagonists amount to glib exercises in reductive comparison). There is certainly a point to be made about the enthusiastic reception of *govern me harder* in much the same New York streetscape where Fluxus emerged in the mid-twentieth century. In due course, theses and exhibitions will address Turato's oeuvre in relation to the formidable modernist genealogies of the problem Johann Gottfried von Herder diagnosed in his *Treatise on the Origin of Language*—Nietzsche called it the "prison-house of language."

Yet Turato's work brings distinctly Yugoslav legacies to bear on the current profusion of language across digital media. In this context,

case studies in state-socialist conceptual and new-media art prove fruitful in expanding the North American reception of Turato's work on matters beyond the terms of internet argot. These lesser-known points of reference expose a certain prehistory of Turato's fixation on language and its transformations along circulatory routes of meaning. Some of these antecedents include the Belgrade composer and painter Vladan Radovanović, noted for his 1975 conceptual text recording *Voice from the Loudspeaker*; the graphic designer, painter, and theorist Ivan Picelj and the New Tendencies movement he cofounded in 1961 in Zagreb; and the Belgrade-born, Zagreb-based poet and installation artist Mladen Stilinović.

Turato's practice combines something of Picelj's geometric formal experiments, his interest in technology, and the total transmedial scope of New Tendencies' creative activity with Stilinović's instinct for semiotics, rhetoric of control, and concern with the economy of creative labor. Her work shares myriad preoccupations with socialist Zagreb's neo and retro avant-gardes, be it the technologically mediated circulation of language, signification and the linguistic infrastructure of meaning, or arbitrariness and its visual, textual expressions. Indeed, Turato might as well be the last Yugoslav artist.

Think briefly about the cadre of contemporary artists across the former Yugoslav republics that command international representation. Among Croatian artists who came of age in the aftermath of socialist collapse, Turato is distinct not least because her work is unconcerned with romanticizing, criticizing, negotiating, or otherwise addressing itself explicitly to the Yugoslav and post-Yugoslav past. Yugoslav modernism is a kind of naturalized heritage in Turato's genealogy, but it is certainly not her subject matter.

Turato's vitreous enamel wall panels—with high-gloss surfaces that are meticulously hand-made, so as to look like they are industrially produced objects—have an antecedent in the egregiously rough-hewn replicas of the constructivist paintings Stilinović made for *Exploitation of the Dead* (1984–1990), which imitate the visual

rhetoric of revolutionary socialism to expose the depletion of its attendant political meaning. Dubbed "poor objects" for their modest materiality and unceremonious surface affectation, these small wooden blocks, with their irregular silhouettes and unevenly cut edges, suggest the unsteady handiwork of an amateur sign painter. Turato may well be Stilinović's inverse, even if she was unfamiliar with his work when I first asked her about it a year ago (though her father, an architect, knew him socially). It is curious to observe that Turato has never used quotes or excerpts from her native Croatian in her *pool*s, performances, enamels, or murals. One is reminded here of Stilinović's quip: An artist who cannot speak English is no artist.[9]

The phrase "govern me harder" appeared before Turato on a walk with her Italian greyhounds in 2020 during the pandemic. It was printed on an anti-vaccine campaign poster. In its newfound placement on an enamel wall work (p. 43), and as the exhibition's title, its imperative takes on a rather more salacious timbre. It does not plead ironically; however ambivalent, "govern me harder" is a command. Emblazoned in Helvetica against a yellow background, the turn of phrase marshals a force of will that already wields something of the disciplining control it claims to long for.

This is apt, for Turato is a control freak. In *govern me harder*, both the murals and the enamels obscure how punctiliously these varieties of wall application were made. Vitreous enameling, elsewhere an industrial production process used to mass manufacture everything from coated bathtubs to architectural facade panels, requires precision and control from the fabricator's hand. Finely ground glass particles are layered onto steel substrate in a thin veneer of slurry laid out to the artist's design; the application of an evenly distributed high heat fuses the discrete material registers of foreground and background into a single composite field. Some of Turato's enamel wall works are composed of four enamel panels neatly aligned along matched seams, and others are diptychs. The resulting pieces are so streamlined and unitary in appearance that they

summon the high-tech affectations of a factory setting, even as they are closer in nature to craft objects of artisanal make.

The exhibition's murals follow a similar logic of dissimulation. What initially appear to be laminated vinyl decals are painted to Turato's design by the ultracareful hand of her production manager, Claes Storm, an early compadre from the Rietveld Academie whose essential role as maker, confidant, and collaborator the artist is quick to recognize. At 52 Walker, Storm engineered the murals to account for the site's sloping floors and exposed piping. Turato's immersive murals belie the mathematical rigor of their bespoke production with abstract supergraphics, such as nested ovals in cheery hues. Yet the sum effect of enamel panels hung against these murals is to reveal—subtly, in layers—the paradoxical tension of making it look easy.

In their use of words, some of the enamels and murals emulate the timbre of mottos, slogans, and lexical collocations deployed in marketing jargon; other works adopt the piecemeal language of unnamed sources, be they individual or collective speakers. In *you're so vain* (2022; p. 21), the text is in stacked script with the central word engorged, to the joint effect of visual and semantic emphasis on order of magnitude. To its right in the gallery, *all is forgiven* (2022; p. 25) is also hung against the mural *horse sense, goddamnit. showmanship!* (2022; see pp. 18–19), which features attenuated, adjacent ovals (Turato calls these "pills"). In its graphic layout, *i sold it for million bells* (2022; p. 47) approximates cigarette-pack public health warnings, addressing itself to no particular public. In *do the dogs eat the dog food* (2022; p. 39), the text is neither statement nor question; the word "dogs" is cleaved into two stacked pairs of tumescent, polychromatic letters. Such typographic effects express the back-and-forth of recursive feedback between formal pattern and semantic sense. Taken in concert, the clipped phrases in Turato's bespoke Helvetica52 that line the gallery's perimeter recall in their strained atmospherics the variform chorus of ancient Greek drama. Yet these clauses and expressions do not amount to concrete, mutually intelligible

communication so much as an environment of alien words and dissonant accents.

What is said by Turato's intermediated cant is the heteroglot consciousness of a contradictory and multilanguaged world. Cacophony, in all its particulars, is routine spectacle.

Notes

1 Nora Turato in conversation with the author, November 10, 2022. Subsequent quotes from the artist, unless indicated otherwise, are from this conversation.

2 See Svetlana Boym, *Architecture of the Off-Modern* (New York: Princeton Architectural Press, 2008).

3 For background on this subject, see Maria Todorova, *Imagining the Balkans*. Rev. ed. (Oxford, England: Oxford University Press, 2009), pp. 140–142.

4 For more on this subject, see Maroje Mrduljaš, Vladimir Kulić, and Wolfgang Thaler, *Modernism In-Between: The Mediatory Architectures of Socialist Yugoslavia* (Berlin: Jovis Verlag, 2012).

5 Turato is not a historicist, and as such this reading of her work does not engage the many modernist vectors of word and image with which her work may be consonant.

6 Nora Turato quoted in Ana Janevski and Nora Turato, "Pools of Performance: Nora Turato on the Found and Spoken Word," *Magazine*, March 2, 2022, https://www.moma.org/magazine/articles/705.

7 "Real speech, when paid close attention to, forces us to realize how little one needs to do in order to write. Just paying attention to what is right under our noses—framing, transcription, and preservation—is enough. . . . The rise of appropriation-based literary practices: Suddenly, the familiar or quotidian is made unfamiliar or strange when left semantically intact." Kenneth Goldsmith, "I Love Speech," Poetry Foundation, January 6, 2007, https://www.poetryfoundation.org/articles/68773/i-love-speech-56d248607161f. "The term *poetry* has come to be understood less as the lyric genre than as a distinctive way of organizing language—which is to say, the *language art*. *Poetic* language is language made strange, made somehow extraordinary by the use of verbal and sound repetition, visual configuration, and syntactic deformation. Or again, it is language perhaps quite ordinary but placed in a new, and unexpected context." Marjorie Perloff and Craig Dworkin, introduction to *The Sound of Poetry / The Poetry of Sound*, ed. Marjorie Perloff and Craig Dworkin (Chicago: University of Chicago Press, 2009), p. 7.

8 Yoko Tawada, "The Art of Being Nonsynchronous," in Perloff and Dworkin, eds., *The Sound of Poetry / The Poetry of Sound*, p. 193. Poetry, in Tawada's account, calls attention to structures such as sound while damping the denotative impetus of language.

9 See Mladen Stilinović's work *An Artist Who Cannot Speak English Is No Artist* (1992), held at the Van Abbemuseum, Eindhoven, the Netherlands.

PLATES

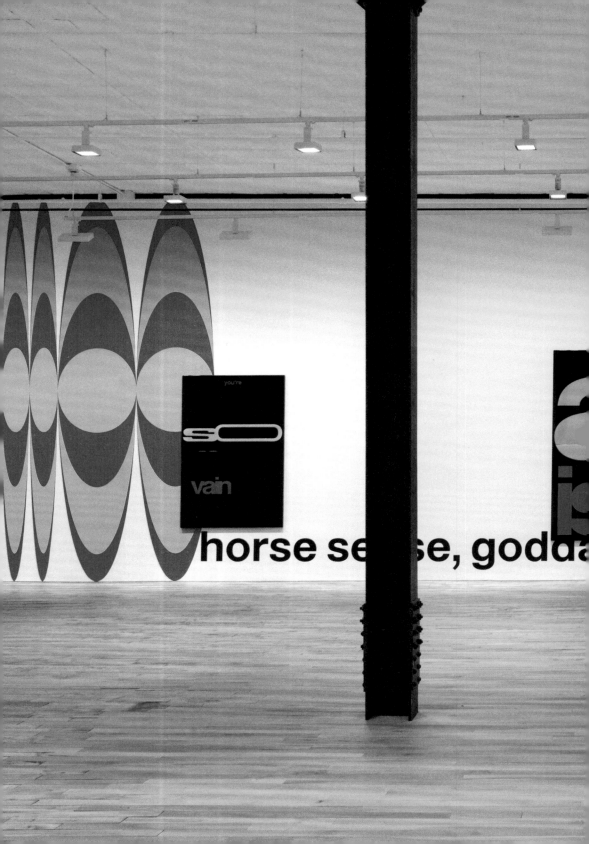

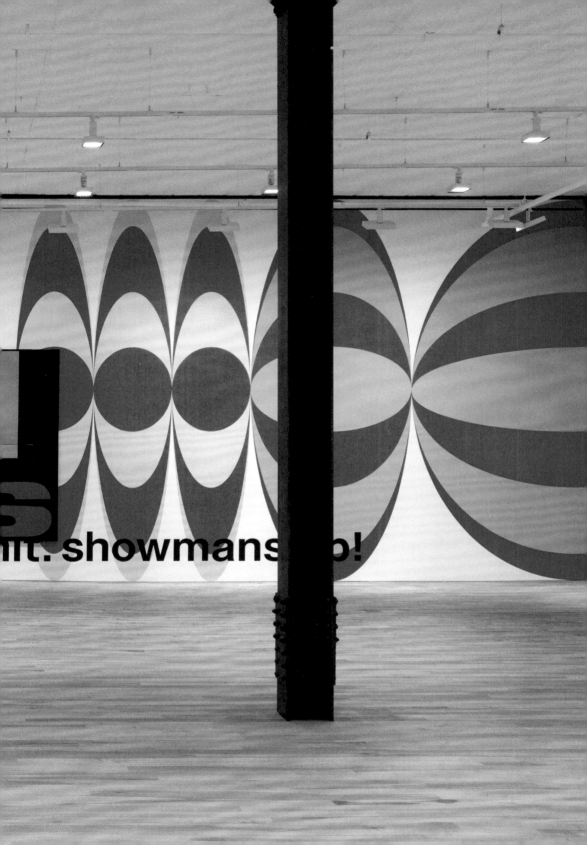

you're

so

vain

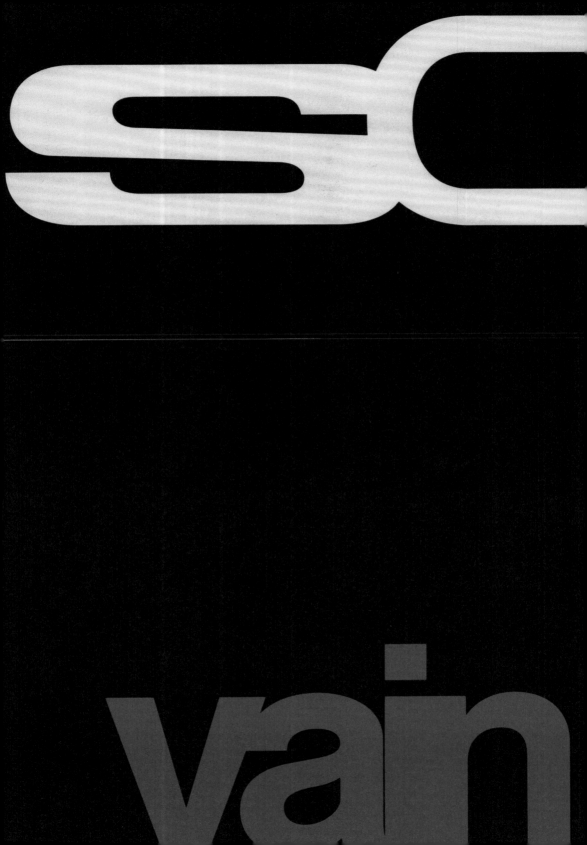

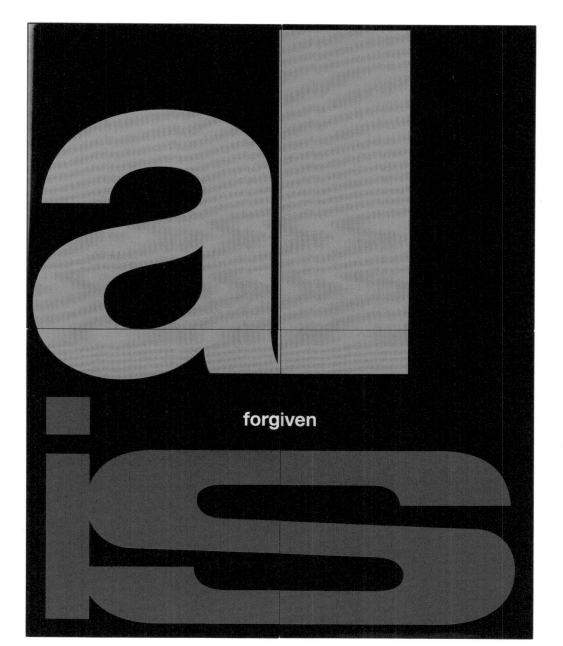

forgiven

for

iven

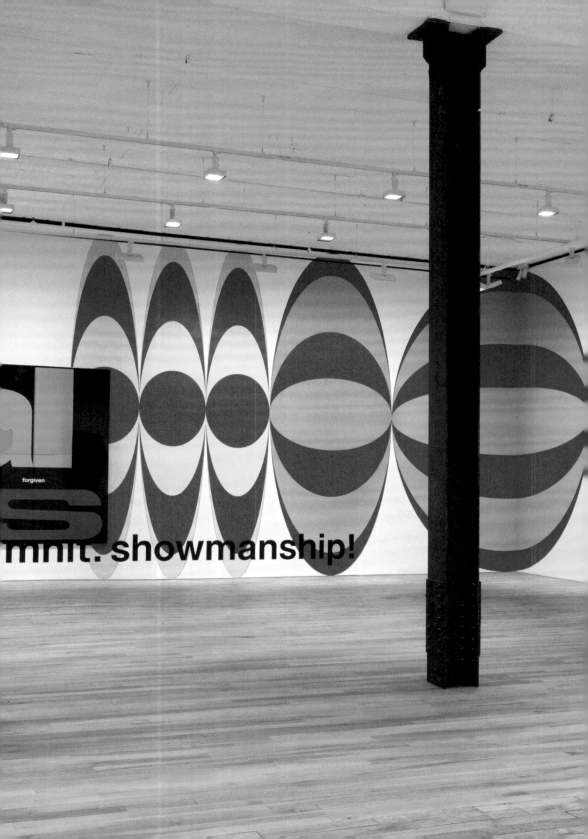

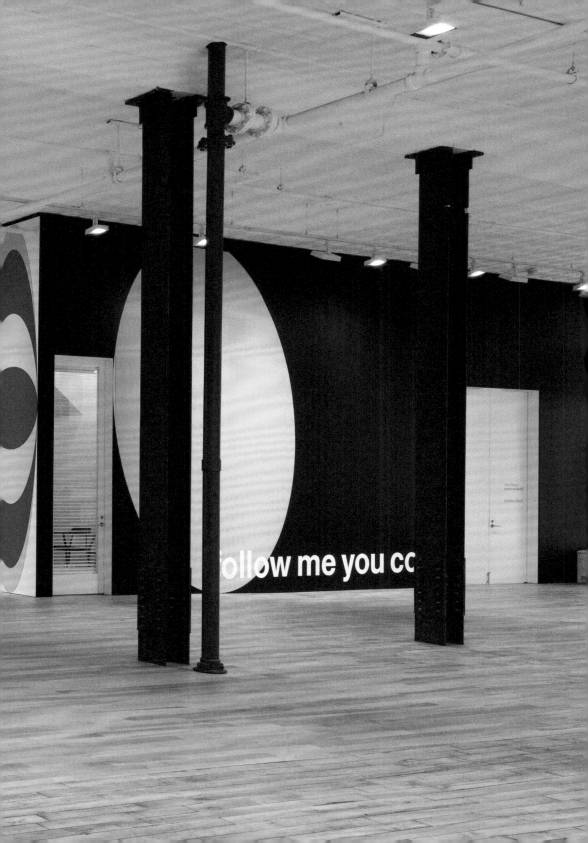

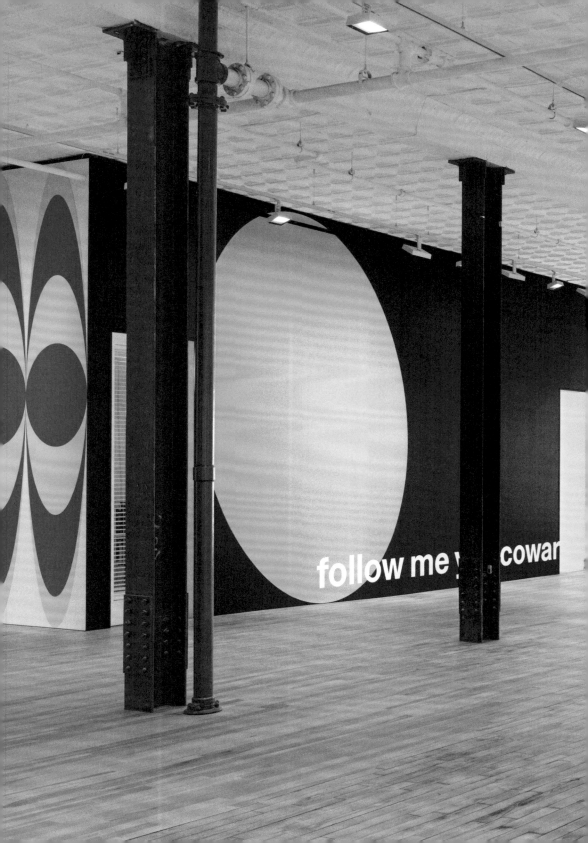

.

.

do they? they do, 2022

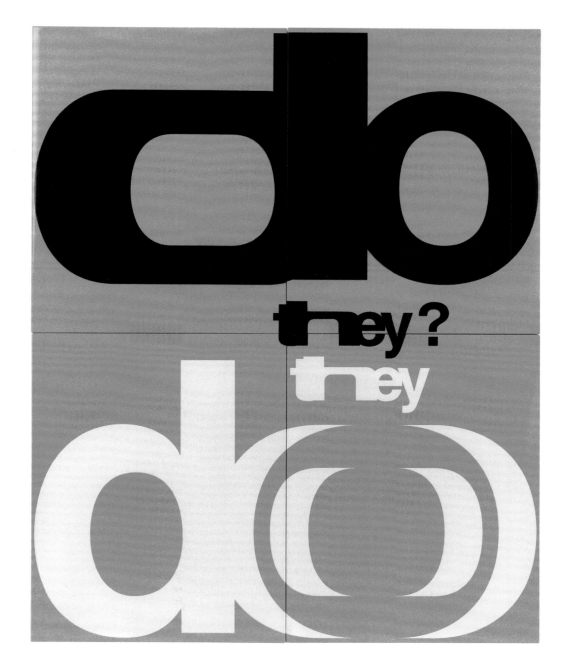

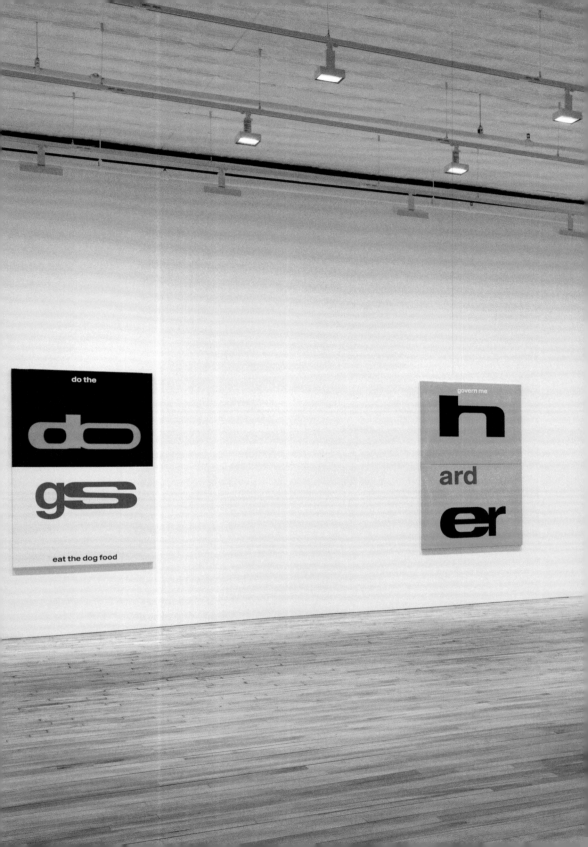

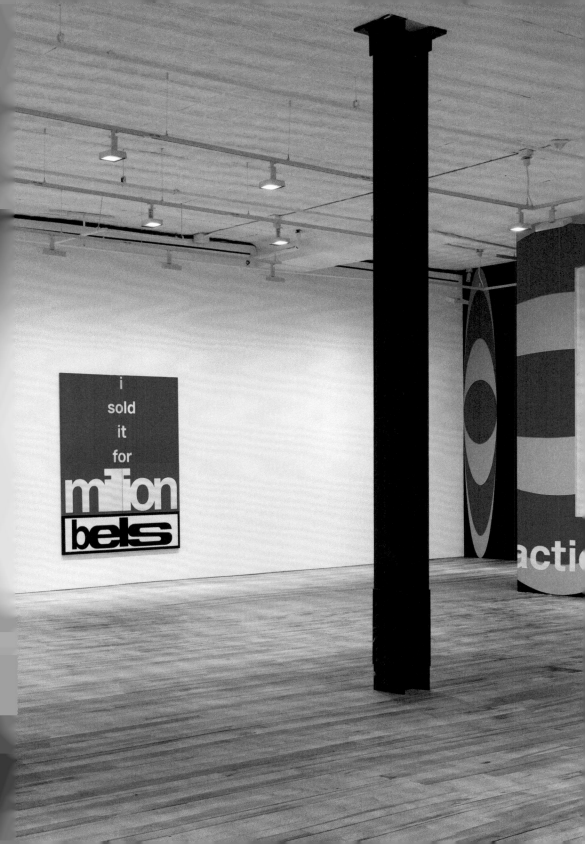

do the dogs eat the dog food, 2022

do the

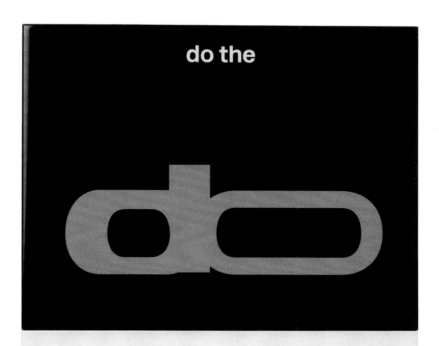

eat the dog food

eat the

dog food

govern me

h

ard

er

i sold it for million bells, 2022

i

sold

it

for

million

bells

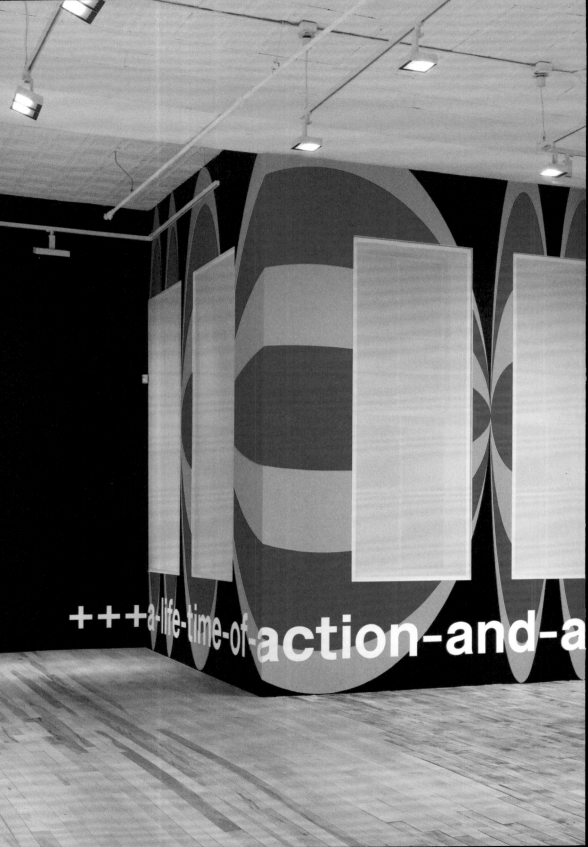

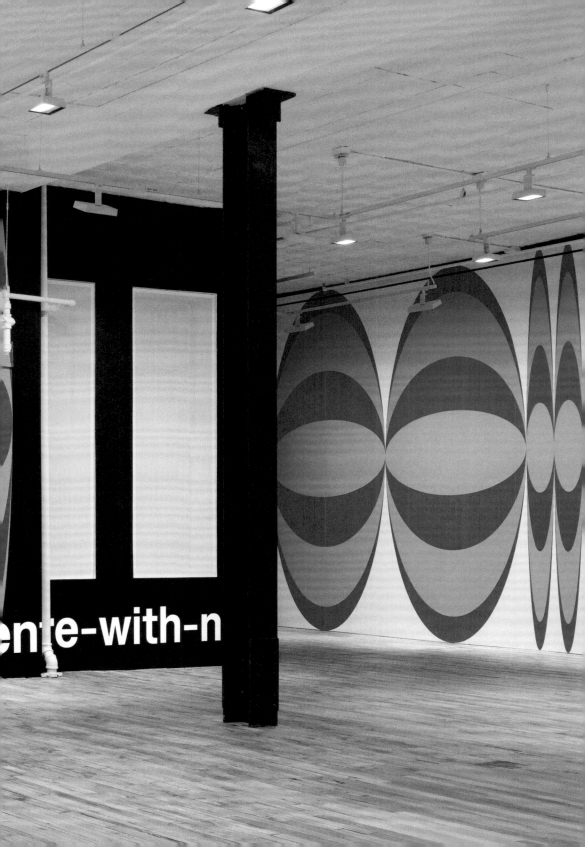

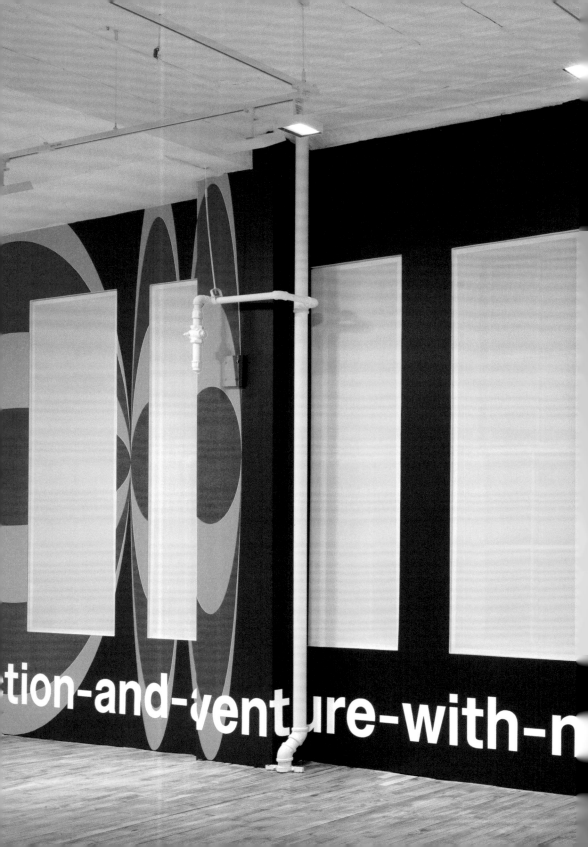

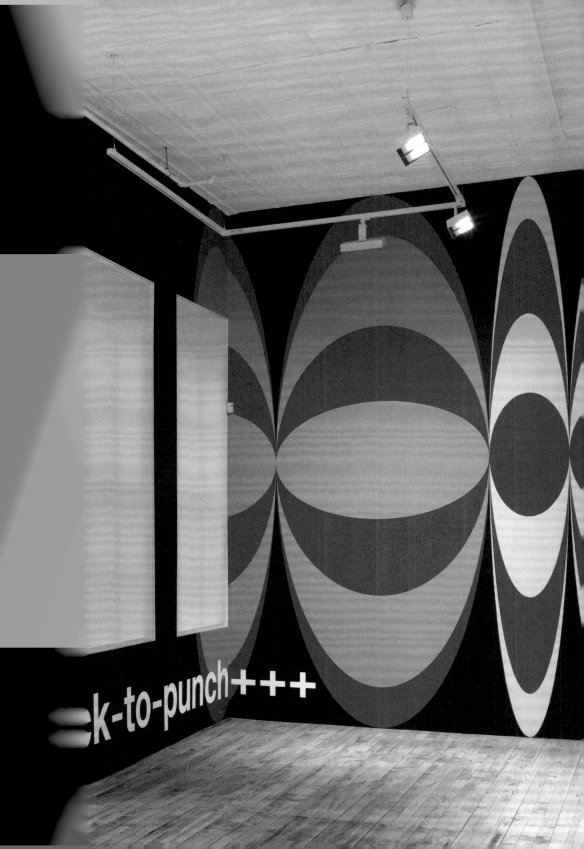

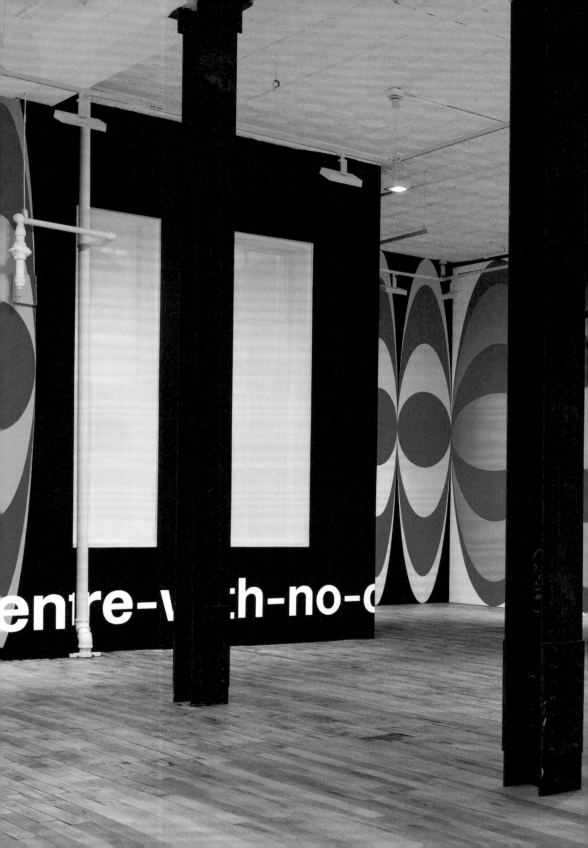

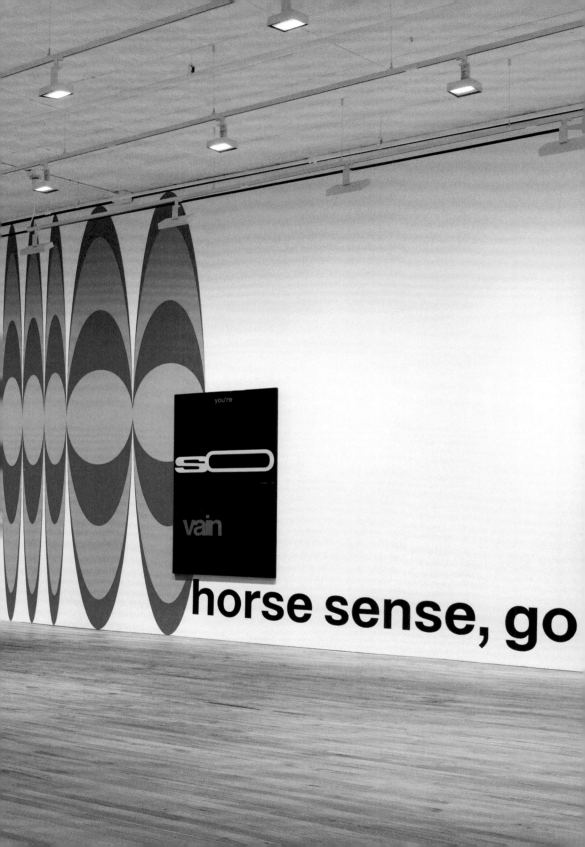

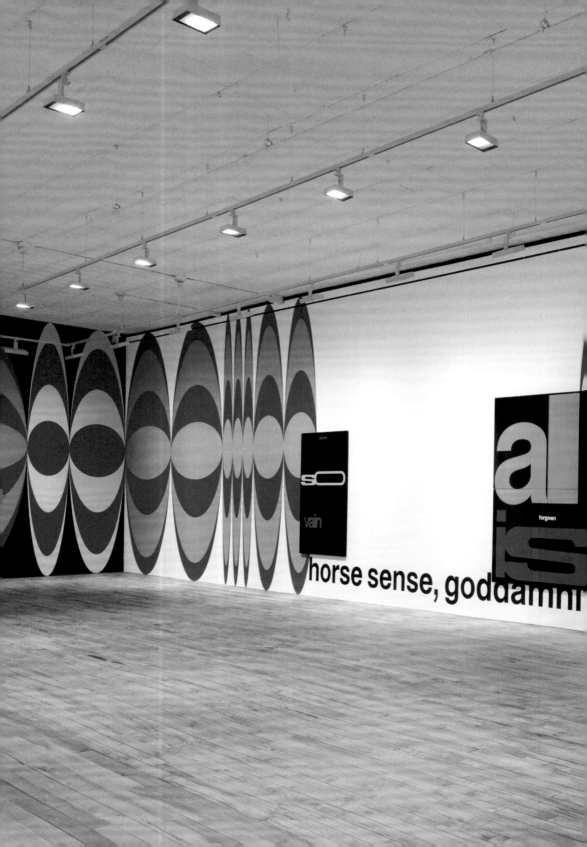

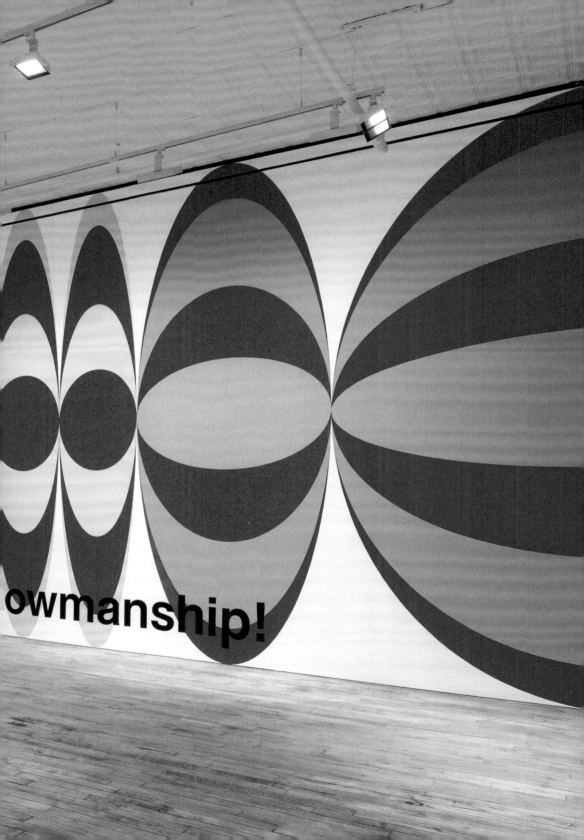

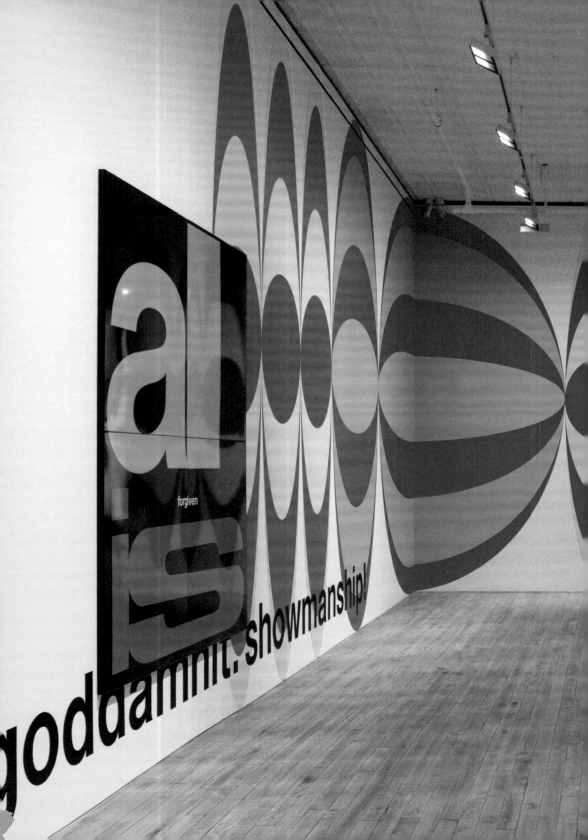

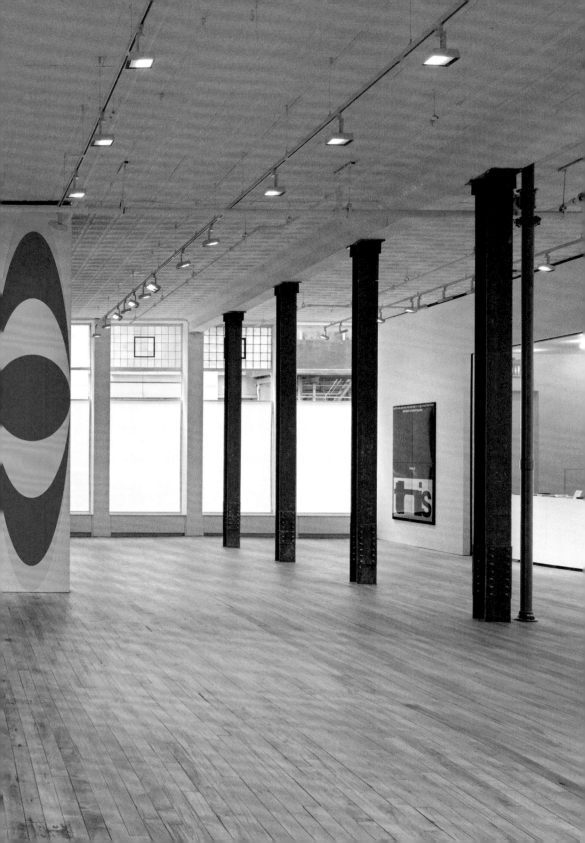

and i'm like dah dah dah dah dah is it right that blah blah blah blah and he'll say yes,
but think of this, 2022

and i'm like dah dah dah dah dah is it right that blah blah blah blah? and he'll say yes,

but

think of

this

and i'm like dah dah dah da
blah blah? a

but

th

lah is it right that blah blah
he'll say yes,

of

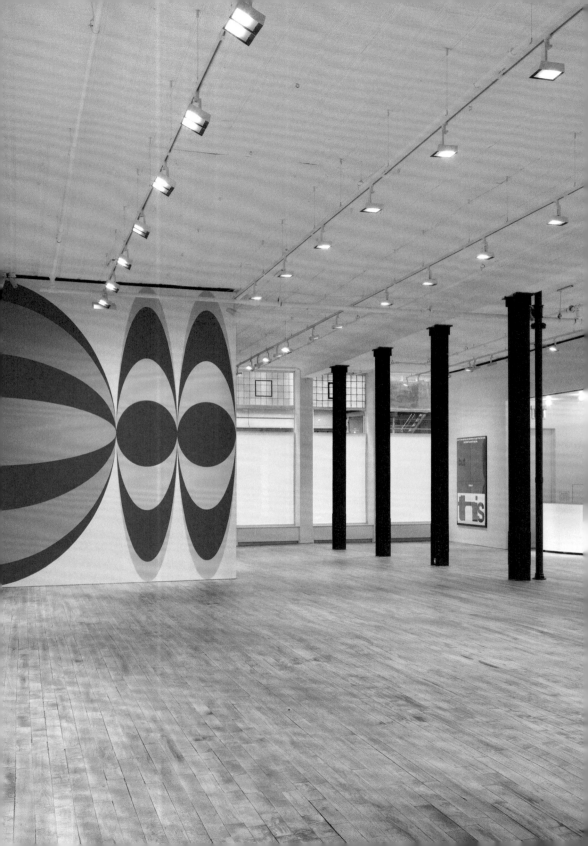

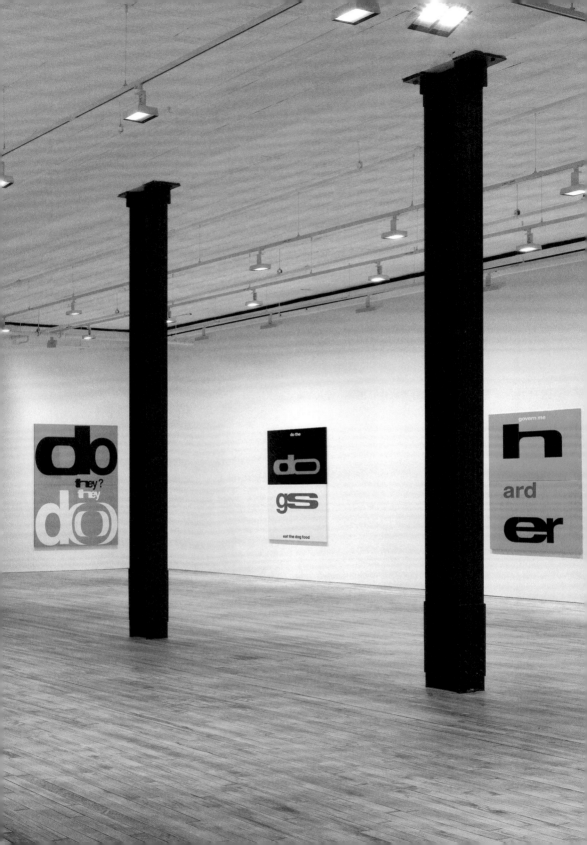

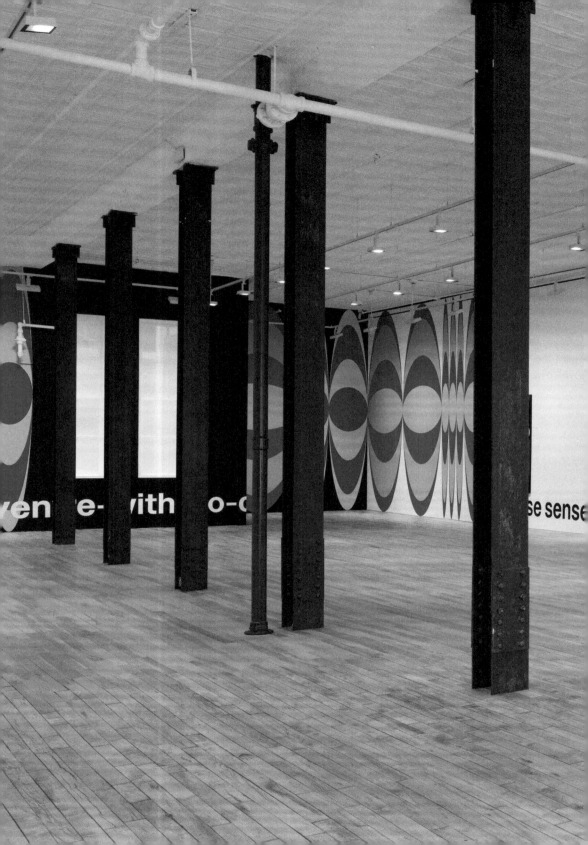

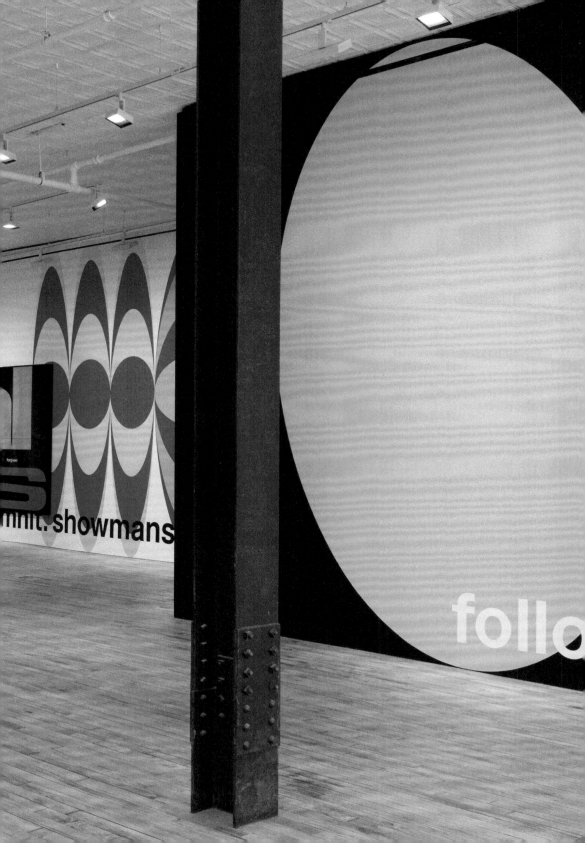

Performance Scripts (Extracts)
Nora Turato

The scripts on pages 69 to 79 comprise extracted pages from Nora Turato's performance produced on the occasion of her solo exhibition *pool 5*, at The Museum of Modern Art, New York, March 5–20, 2022. They appear true to the original script pages typeset by Turato.

Cold rea*dings*
Dings dings dong

You know nouuu not naaa
Walking b ackwards opportunity to warm up
NEED AIR [Sooo.ya know].[feel vib in chest,not just
emphasizing,need to warm up before you go on and maintain vibration
i.e no air when you say "walking backwards..]Walking backwards[air] forces
you to kuh-nEkt to your bAH-dee in a whole new way
and relate dlf-ruhnt-lee to your own mOOv-muhnt.
It also in-gAY-juhz mUHs-uhlz that don't get used as much as those used in regular
walking.

[above bit is opportunity to have a solid foundation{ sets the tone} for
rest of performance

[slightly drunk sounding.slurry..intentional? More emphasis on
emphasis than WHAT you are talking about-like when you started
doing sci-fi guy]Ooooook Soooooooooo (golden) suh [soo-can be fast long O
but not SUH] I started
i star-DIDa (i began, the sense) [intentional pushed emphasis?] THi*ssss*
bizzzzinisss,(PROOOOHHHwwTINnnna barzz) initially aZZZ an oNnnnnLajiiiiiiiN shop,
in ccccwo THousannnnddddda THrTeennnnna, after (e!) obserlNVNNGGGG
this treNNNddda for
egzaaaadickleeee-fleeeeiiivvvrd PROOOOHHHwwTINnnna barzzzzin THeee US.
Aaaaatt [th]at time, I wus **ann** *avvvVvvvviddddDa*
giiiimmm-gowwwwr (jim lawn mower), and PROOOOHHHwwTINnnna barzzz were just
starDDDDinnnnngggg to be a lit-tull more krieeeeeiijjjIDIV, a lit-tull more X-SIGHEEE DING.
PEEPULL were actuaLLI PUDDING * effort inCCCCUU the FLEEEIIIIIVVVRa, and it began to
transcend this bland, functional: u know 'we're just going to ram some protein in you.'
The tehchologyyyyyy (tttttech as in tell, air) behind PROOOOHHHwwTINnnna barzzz has
evolved to the point where they are almost identical to ordinary chocolate
barZZZ. It's incredible how much this stuff has become mainstream.
When my grandma starts eating protein bars, that's a profAwwwnd cultural shift u see … she
loves them. She's buying boxes of that stuff. Its Like you can have **any** snack you like, **as**
loOOOng as it comes wiTH extra PROOOOHHHwwTINnnna.

...

...

Now (nauuuuuuuuu cow) you have
Extra Pr PROOOOHHHwwTINnnna pancakes (SJP), oats, muffins chipss, nachos,
PROOOOHHHwwTINnnna croissantzzz shakes. all packed with extra
PROOOOHHHwwTINnnna And PROOOOHHHwwTINnnna barzzzz, of course!
PROTEIN BARS! I love protein barZZ, they come in so many fun flavours, I wanna try them all
they got Ssssalttttttty (iiiiii) caramel hazelnut fudge,
crunchYIIII peanut butter with toasted almonds and coconut
CAShU crunnch
Cookeey (iiiiii) dough mint chocolate chip double chocolate fudge
EXTRA bIIIIig, JUICY and CHew+**weeee** chunks
lemon drizzle cinnamon SWIRLZZZZ white chocolate chip cookie brownie CRUNCH
BUUUUUTT!! protein!!!
OBBBBVVviouslEEEEE (iiiiii), some r guDDD and some r not; not ALL the protein bars are
may-DEEqual u see... it's really(iiiiii) a hit or a miss for me
or *a miss for me*

But im glad to be back doing this You know why I
stopped (drunk) righttttt
My shOHI-duhr I coulDUNT (dunt cunt) write on the whiteboard
(white-a boarDa TATATA)anymore
I had my ***shOHI-duhr*** ri-plAYst
I got a metal ball In there now
ahr-tuh-flsh-l joint
And I am
Look at this
Im golden GOOOLDEN]
so... my handwriting still sucks.
so you still have to interpret what I write.
But it's worth the price of admission because I got a great topic for
today.
And itsss stemsZZ from this ridiculously idiotic (idi-o::d-dick odd+dick) poDa-casTa i had
with this guy, who LItter-uh-lee (lee leee leee) in my book knows, knows AS **MUCH** about
salezz **AS** like, I don't know...
LItter-uh-lee (lee lee), the guy knows **NOTHING**. I mean, LItter-uh-lee, I don't get it. Okay,
so I'm very confused about a guy that cant answer the most basssssic questions,
the most basssic questions about selling

...

...

And all he kept saying was you gotta have a **FUHL PiPeLINE** (spit it on airr PPPipppelineee), you gotta have a **FUHL PiPeLINE.** That's, yeah, okay, I get that. Yes. Obviously, obviously, you want a **full PiPeLINE,** you know what that's called?
That's called marketing .I'll put a big M, that's marketing
There is this **HHHUUUUUUUGE**, it seems to be, **misunderstanding** out there, of the distinction between **marketing** and **sales**.

so I called this guy Grant on my pod (PODa),
supposed to be a *great* sales *trainer*
And the guy couldn't answer anything about selling, kept referring back to,
you gadda advertise, you gadd…. people gadda know,
that's marketing pal
And let me just tell you, all of youMARK-E-TERS out there,

do you know　　that all the **BIIIG** marKETers, all the **successful** ones,
they come to **meeee**
Yeah they come to **meeee**

They come to me to sell, to learn how to sell, to increase their Ability to communicate their
ideasZ [air] because here's the deal. Marketing is what brings people into-your -funnel,
[fun-NULL]brings people into your pipeline That's step one.

And yes, you want to be an expert marketer. And thankfully, with, the platform's we have today with online marketing, you can make a *bloody fortune* as an online marketer.
But lemme just tell ya a little secret here, ready?
All the great ones, the ones that **really** make money,
they've also schoooooooooled themselves in selling.
How do you closoe the deal? How do you close??

MARKETING ting ting ting ting brings people into the FUN+ NULLa fun nulllla
(SJP)　　(sliiide)
alright! Brings people into the FUN+NULLa (SJP)
So I kept saying Ok great good ur iN ur FUN+ NULLa now! So what do you do next? What do u say… what do u say first, what do u say second!?? thats what *sales* ARE ALL about.

FUNNELLLLLL!!!!!!!C (IMAGE OF IT)
FUN + NULL

+++Suit the action to the word and the word to the action+++
climb/slide/huge/golden+TEXTURE/DIMENSION 1D to 3D or 5D

U see, dick… u miNd if a call u dick dick

...

...

*My asso*Ciates here would very much like to SEE you have a little accident.
But I tell 'em no.
I'll take care of him myself, I tell 'em. You know why? (who speaking to ?)
I want you on **my** *side*! (SJP)
And let me tell you what **MY!!!** side is.
MY!! side is
+++++a life-time-of-*action*-and-*adventure*-with-no-clock-to-punch.+++
++It's treatin' that gal of yours one hundred percent++.
She should be treated like a princess, protected like a baby.
Fifteen thousand **CLEEEEEuhMS}**.{1940'S GANGSTER ===== **CLEEEEEuhMS}**
It's a deal
Fifteen thousand **CLEEEEEuhMS}!**
Welcome to **new waters** (*my way, special way, the new waters*), Dick!
We're gonna run one hell of a ship with you aboard.
There's a big world out there and its for sale, all of it
There r billions to be made and the only competition
idiots
(welcome to new waters baby)

U see, dick… u mind if a call u dick
Im a king
U see, dick… u mind if a call u dick
Ima king
not because of my immanent fe**atures** but because I occupy a certain place in the
socio-symbolic edifice,
That is, because others treat me like a king.
I STOLE!!! the keys to my *dungeon* under the EYES of guards and
You'll be disappointed to learn that all of my success can be attributed to my
grangrangrangrangradad,
the inventor of
pants

.

I stopped at the mighty river
I sucked the damn thing dry
I may have girlbossed a bit too close to the sun
But that's on me
If u wanna be a woman be a bitch

This is my houSE
my opiniN,
my townN,
my lawnN,

...

...

He acts shy, but he's not.
He's scared.
He hates himself, and he loves himself,
Ermmmmmm
a very tense situation.
It's people like me who have to carry on and to be modest.
To me, it's the most embarrassing thing in the world—a man who presents himself at his worst
to get laughs, to free himself from his hang-ups.
Every thing he does on the screen is **thair-uh-pyOO-tik**

THIS (right over here) Is the WORLDS-LARGEST **oil processing plant**…. located…. In the
EAST-turn pro-VINCE of Saudi Arabia.
EarLEE on Saturday, September 14th,
a sear-eeez of **explo+OOsIons rockED** the **FA-SILL-I-DEE** [the oil processing plant] and the
worlDD W+ o+ook to **see It ..burning]]**
. (but) WHY-yill the **WORLD** was looKING over here,
EN-ER-GEE TRAY-EATERS on W+All Street and else-ware were <u>also</u> looKING over here
and here.
and here
and here
And here
at 1000s of *store-ridge sites* ..around [all over]..the world..
where compaKNEES and counTREES **stocKuh Pie-ile OIL.**
What's <u>**Inn-sighed**</u> these tanks (SJP)(referring to the storage sites) can be
valuable Information (VI SJP) for **tray-eaters**
who make **BIIIG bets** baY-EEsed on **how- much-suppLIE** is A-VEIL-A-BLE , and
where-In-the-world It's LOW-KAY-DID
For [energy]**tray-eaters**, an **event** (referring to the giant explosion tragedy) like **thIs** one
can be an **opportuniTEA (DEE).**

[**Or-bit-al / Inn-sigh-eat**]
Is a **compaKNEE** that *estImates* the tanks **CON-TENSE** uZING saddle-light imageREE,
artI-FISH-ill In-tell-i-gence and a lot of com-pli-kay-DID math
Or/bit/taL is at the vanguarD… of **FIRMS** that **SELL DATA**.. to Hedge funds, enerGEE
compa-KNEES and others… who are looKING to ANN-TISS-I-PAIT **oi-yill pry-ice moves.[SJP]**

To …get their **hands** …on the **data**,
the FURRST thIng thIs compa-KNEE had to do ..was FIND as MEN-KNEE of these-tanks [SJP]
as It COULD.
Employees [of Orbital] **tray-een-ed computers** to **spot them** by feeDING them… image
after image.. of oil tanks..
once… the computers …got the *picture*,

...

...

 advanced biological research,
 the **development** of synTetic BAAAAACK-te-ria (president)
Against-which we *may* have no defense
SINISTERdevelopments one sees in *computers*

and the sort of **The control** over **every** aspect of our lives that **eeedvanced data processing tttttechhhhhniques** provide (tech aiiiirrrrr advanced w croatian e)
on a huge-RAAAAAAAANGEEE of themes
science fiction u know
(ever since) Since the day-zzzzzovvvv *(looking for a name, processing)*
WWWWWWWellzzzzz has been **remarkably accurate,** I think, in predicting
the kind of sort of .naaah. u know …
very confused and uncertain response to *these changes* (changes i just told u about)

The **one** *mistake* in a way, the one..
the one way in
which **sigh-jjjiiiiiiiinc (like mince 2 syllables)**
traditional **sigh-jiiiiinc** fiction **handicapped itself,**
was to project this,
it's it's **its** **(sfi)** **very** accurate predictions into the **faaaaarrrr** future
and into **ouwwwwter** (aaaauuuchhhhh space) space so that you have this sort of paradoxical thing of
sigh-jiiiiinc fiction was **bringing** you the news,
but it was…
First
before you could see it,
it was **re** - *enacting it* as a sort of Star Trek episode
You know,

We **arrrwatching**(passive) the news on television,

we-never-actually-**saw** (SJP) the war in Vietnam, (difference betweeen looking and seeing)

we only saw a space war a million years from now, this is this is this is **A pity**.

It's one of the things that I I tried in my small way to change when I started writing it

there was there was this sort of paradox that
you know,
up to,
I suppose, **the** 1950s,
one could assuuu.... i mean ,sort of,
assume this **relationship** between reality and and and

+++*a life-time-of-action-and-adventure-with-no-clock-to-punch*+++, 2022
Emulsion paint on wall
Dimensions variable
Private collection, Maryland
Pages 50–53

all is forgiven, 2022
Vitreous enamel on steel in four parts
Overall: 94 ½ × 75 ⅝ inches | 240.1 × 192.1 cm
Collection of Eleanor and Bobby Cayre, New York
Page 25

and i'm like dah dah dah dah dah is it right that blah blah blah blah and he'll say yes, but think of this, 2022
Vitreous enamel on steel in four parts
Overall: 94 ½ × 75 ⅝ inches | 240.1 × 192.1 cm
Private collection
Page 61

do the dogs eat the dog food, 2022
Vitreous enamel on steel in two parts
Overall: 75 ⅝ × 47 ¼ inches | 192.1 × 120 cm
Private collection, Switzerland
Page 39

do they? they do, 2022
Vitreous enamel on steel in four parts
Overall: 94 ½ × 75 ⅝ inches | 240.1 × 192.1 cm
Private collection, Switzerland
Page 33

follow me you cowards, 2022
Emulsion paint on wall
Dimensions variable
Pages 28–31

govern me harder, 2022
Vitreous enamel on steel in two parts
Overall: 75 ⅝ × 47 ¼ inches | 192.1 × 120 cm
Private collection
Page 43

horse sense, goddamnit. showmanship!, 2022
Emulsion paint on wall
Dimensions variable
Rennie Collection, Vancouver
Pages 18–19, 56–59

i sold it for million bells, 2022
Vitreous enamel on steel in four parts
Overall: 94 ½ × 75 ⅝ inches | 240.1 × 192.1 cm
Private collection, Asia
Page 47

you're so vain, 2022
Vitreous enamel on steel in two parts
Overall: 75 ⅝ × 47 ¼ inches | 192.1 × 120 cm
Scheinman Family Collection, New York/Paris
Page 21

David Zwirner and Ebony L. Haynes wish to thank Nora Turato, without whom this exhibition and publication would not have been possible. Thanks are due to Anna Kats for her thought-provoking essay.

For their work on the exhibition, we are grateful to Rebecca Ashby-Colón, Claire Ball, Susan Cernek, Allison Chipak, Cristina Covucci, Ojive DeLungéla, Karryl Eugene, Clara Gordon, Coco Kim, Vida Lercari, Thomas Ling, Julia Lukacher, Alyssa Mattocks, Kerry McFate, Sean Morgan, Clive Murphy, Julian Phillips, Kyle Rafferty, Robert Richburg, Gabriela Scopazzi, Janna Singer-Baefsky, Virginia Stroh, and Nora Woodin.

Thank you to Andrea Hyde for the catalogue series design and, for their work on this volume, to Sergio Brunelli, Luke Chase, Fabio Ferrandini, Zeno Ferrandini, Doro Globus, Elizabeth Gordon, Amy Hordes, Jessica Palinski, Mari Perina, Molly Stein, Jules Thomson, Joey Young, and Lucas Zwirner.

The artist would like to thank Julie Adams, Sabo Day, Ana Janevski, LambdaLambdaLambda, Jungmyung Lee, Marta Perovic, Nicholas Riis, Galerie Gregor Staiger, and Claes Storm.

The *Clarion* series is an essential component of 52 Walker programming. An edition will accompany every exhibition, highlighting and expanding on the show's conceptual theses through newly commissioned texts, interviews, archival materials, and artistic interventions. The series is named in honor of the renowned author Octavia E. Butler, who was first published in the 1971 Clarion Science Fiction and Fantasy Writers' Workshop anthology.

Other Titles in the *Clarion* Series
I. Kandis Williams: A Line
II. Nikita Gale: END OF SUBJECT

Forthcoming Titles
IV. Tiona Nekkia McClodden: MASK / CONCEAL / CARRY
V. Tau Lewis: Vox Populi, Vox Dei

Published by David Zwirner Books
on the occasion of

Nora Turato: govern me harder
52 Walker, 52 Walker Street, New York
April 8–July 1, 2022

David Zwirner Books
520 West 20th Street
New York, New York 10011
+1 212 727 2070
davidzwirnerbooks.com

Editor: Ebony L. Haynes
Project Editor: Elizabeth Gordon
Editorial Coordinator: Jessica Palinski
Proofreader: Chris Peterson

Design: Andrea Hyde
Photography Coordinators: Rebecca Ashby-Colón,
 Allison Chipak, Virginia Stroh
Production Manager: Luke Chase
Color separations: VeronaLibri, Verona
Printing: VeronaLibri, Verona

Typefaces: DTL Fleischmann, Genath, Arial
Paper: Magno Natural, 140 gsm

ISBN 978-1-64423-086-2

Library of Congress Control Number: 2023903975

Printed in Italy

Notes

Notes

Notes